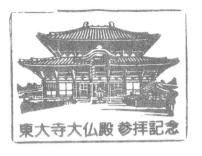

東大寺大仏殿 参拝記念

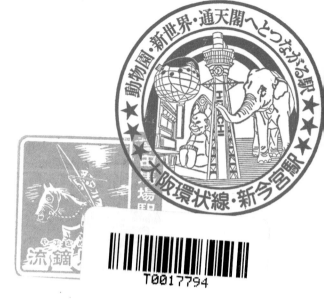

動物園・新世界・通天閣へとつながる駅
HITACHI
大阪環状線・新今宮駅

流鏑馬

T0017794

宮島ロープウ

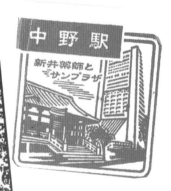

中野駅

新井薬師と
サンプラザ

北海道神宮

街と繁華街の拠点駅

★★
★★★

東西線・北新地駅

日本100名城

54 大阪城

ABBY DENSON

UNIQUELY JAPAN

Discover What Makes Japan The Coolest Place on Earth!

TUTTLE Publishing

Tokyo | Rutland, Vermont | Singapore

CONTENTS

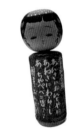

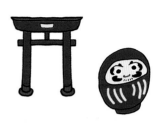
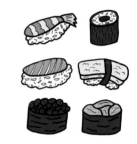
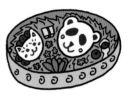

SWEETS

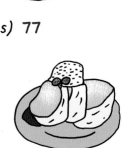

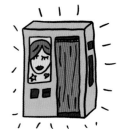

HIGH TECH

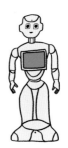

CREATURES

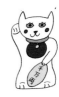

STREET SIGHTS

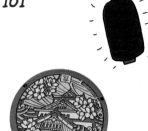

SIGNS

EVERYDAY CUTENESS

STAMPS

THE COOLEST PLACE ON EARTH!

Welcome, and thanks for joining me on this journey through some of my favorite things about Japan!

Over the years I've spent regularly visiting Japan and gathering inspiration for my guide books, Cool Japan Guide and Cool Tokyo Guide, I've taken loads of photos and enjoyed learning about so many interesting details that stand out because you won't see them anyplace else.

I'm thrilled to now share some of my illustrations, notes, and photos I've collected across a decade of visiting one of my favorite places in the world. The most challenging thing about creating this book was choosing topics. The number of things that are unique about Japan could fill volumes. So I approached this project as an opportunity to share my own personal faves, but even choosing among those—let's just say that, deciding what I love best about Japan would be a lifelong project.

Some topics not covered here that I hope you'll take time to explore include sumi-e ink drawing, performing arts, games, sports, and many different traditional artisanal crafts.

I hope you'll enjoy reading about my faves, then go out and find your own. You'll find that each new subject takes you down yet another fascinating avenue. As time goes by, the list will grow and you'll find that there will always be something new and interesting to discover about Japan, and the world around you!

Abby D—

When planning a trip to Japan, a great place to start is by taking note of the seasons. Nature and the change of seasons is a huge part of Japanese culture.

The influence of Shinto, the native animistic religion of Japan, is evidenced by the many shrines seen and regularly visited by locals and tourists alike.

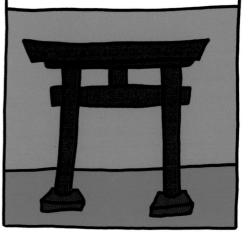

Nature's beauty and the seasons are celebrated in many ways, especially in foods that are featured in traditional restaurants, and even chains such as Starbucks regularly offer seasonal specialty drinks that are found only in Japan!

kabocha!

Special drinks!

Persimmon!

Strawberry!

Cherries!

People often ask me the best seasons to visit... While my favorite season is autumn, I don't think there is any absolute bad time of the four seasons to visit Japan, though you may want to skip the rainy season (tsuyu) which is early June-mid-July.

Spring

春
HARU

Spring is a gorgeous time to see Japan, and also one of the most popular times to visit. Nature is beginning to awaken from its long winter sleep, and the flowering of trees is celebrated with festivals. First to bloom around February and March will be the plum blossoms, and plum blossom festivals (ume matsuri) are held across the country. But the main event of the season is the arrival of the cherry blossoms (sakura)! Sakura are the unofficial national flower of Japan and there are cherry blossom forecasts to help everybody plan the best time for their hanami (sakura viewing) activities.

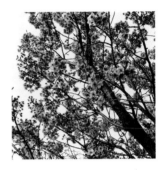

Ume
Blossom

Bamboo
shoot

Cherry
Blossom

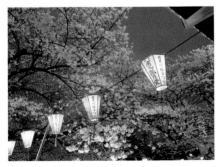

The fleeting nature of the short season of sakura makes us feel more mindful of unstoppable forces of life and nature and the passing of time. Watching the blossoms bloom and blow away on the wind over the short blooming season is gorgeous and can be a very contemplative experience. At the peak bloom people picnic with their friends as they all enjoy the sight of the sakura in full bloom. And of course there are sakura-themed desserts and drinks to enjoy throughout the season!

9

Summer 夏
NATSU

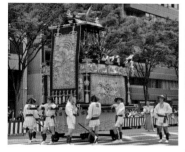

Summer in Japan is extremely hot and humid, but it's also the time you can see many festivals! Gion Matsuri in Kyoto is one of the most famous, with a spectacular float procession (Yamaboko Junko) on July 17th. Festival atmosphere is a lot of fun with many attendees wearing yukata (light summer kimono), and food stands with yakitori, shaved ice (kakigori), candied fruits, and many other fun festival foods and games. Hanabi (fireworks) are another popular summer attraction and hanabi festivals can be found all summer long.

Summer is the time for Obon, the Buddhist tradition of honoring the ancestral dead. The ancestors' spirits are believed to visit their families' household altars. Families gather and hang lanterns and make offerings of food at altars and temples for their ancestors. Telling ghost stories (kaidan) to give the listeners a scare to chill them is also a summer tradition!
Here are some other tips to stay cool: Eat kakigori (shaved ice)! Drink frozen Kirin beer! And of course, make sure to drink plenty of water.

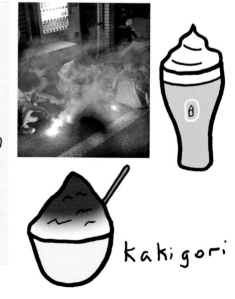

kakigori

Autumn

秋
AKI

Matsutake

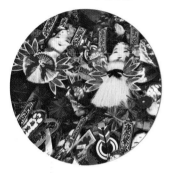

Autumn is my favorite time to visit Japan! The leaves change to gorgeous colors and leaf-viewing (momijigari) is a popular activity. Some parks and temples hold amazing illuminations where the brilliantly colored trees are lit up for special night viewings! Kiyomizu temple's autumn illuminations in Kyoto are especially stunning. Halloween brings all kinds of spooky fun and decorations to the shops and restaurants, and sweet potatoes, mushrooms, chestnuts, and persimmons are featured in the delicious seasonal dishes.

In November, the Shichi Go San festival features children of 3, 5, and 7-years old dressed up traditionally to receive blessings at shrines, and the Tori-no-Ichi festival is a great time to try out snacks at the many food stalls and buy elaborately decorated bamboo rakes that are meant to rake in luck for the following year!

Chestnuts

Yaki Imo

Kabocha

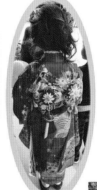

Persimmon

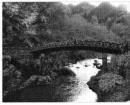

Winter

冬
FUYU

Winter in Japan is a great time to enjoy gorgeous holiday illuminations that are set up in parks and shopping centers of major cities. Sapporo has a famous snow festival in February every year. It features snow sculptures, concerts, and more. Christmas is a romantic date night, and Kentucky Fried Chicken party barrels are popular for celebratory meals. For dessert, a popular treat is Christmas Cake, a lovely strawberry shortcake! Another winter tradition that's enjoyed on the winter solstice (toji) is to take a hot bath with the fragrant citrus fruit yuzu added to ward off illness in the coming year. Mochi is also traditionally eaten to celebrate the New Year.

Mochi

Christmas Cake

The New Year in Japan is celebrated with family by cleaning the house, making the first shrine visit of the year (Hatsumode), and enjoying Osechi Ryori - traditional New Year foods. These include sweet black soy beans, herring roe, dried anchovies, and shrimp. It's also traditional to eat soba soup, the noodles representing a long life and good luck!

Arts
+
Crafts

Japan is the home of many unique and important traditions of art and design. From ancient crafts, to pop culture, there is so much to experience!

Of course, manga and anime are two of the most influential examples of Japanese arts. Comic artists and animators around the world are inspired by the techniques of manga authors of Japan.

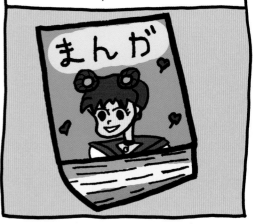

Classical arts like shodo calligraphy and mask-making are still enjoyed and practiced. At every turn, there are opportunities to experience and learn about the arts and design of Japan!

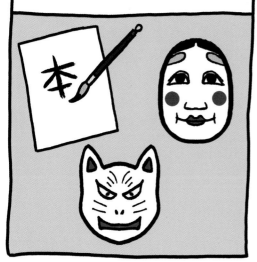

Something even as seemingly basic as stationery has a unique twist on it. Beautifully decorated washi tape has become a phenomenon with crafters globally!

Manga

まんが
COMICS

Manga is the Japanese word for comics. Narrative visual storytelling in Japan began long ago with art painted onto paper scrolls and folding screens during the 12th century and was featured in woodblock prints made during the 17th-19th centuries. In the 1930s and post-war Japan, kamishibai, a form of storytelling entertainment was popular. It was performed by street vendors who narrated the tales while manipulating illustrated boards in a screen-like box. This was also an influence on what manga was to become.

Osamu Tezuka, known as the "God of Manga," revolutionized Japan's comics and animation industries over his long career.

Having survived an air raid during World War II as a youth, his philosophy was to teach peace and respect for all life through his work. He worked in many different genres, showing the potential for manga and anime to convey a universe of stories. Girls' manga, boys' manga, cooking manga - manga can be found on almost any topic. Manga is for everybody! There are even murals (one pictured above) dedicated to Osamu Tezuka near Tokyo's Takadanobaba station. Check out the Tezuka Osamu Museum and the Kyoto International Manga Museum to learn more!

Origami

折り紙

PAPER FOLDING

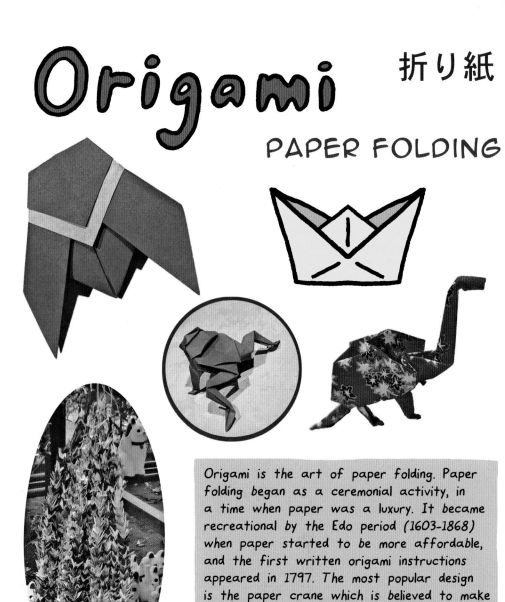

Origami is the art of paper folding. Paper folding began as a ceremonial activity, in a time when paper was a luxury. It became recreational by the Edo period (1603-1868) when paper started to be more affordable, and the first written origami instructions appeared in 1797. The most popular design is the paper crane which is believed to make one's wish come true. It's traditional to give a seriously ill person 1,000 paper cranes to wish them a fast recovery. Origami is a fun and inexpensive hobby. Try it out!

Shodō

書道

CALLIGRAPHY

Shodo is traditional calligraphy, the way of artistic handwriting. Introduced to Japan from China circa 600, it is used as part of Zen Buddhist practice. It's taught as regular curriculum in Japan's elementary schools and junior high. It's a popular club activity in high schools too! Shodo classes are available in many countries globally, and they are really fun and interesting. Give it a try!

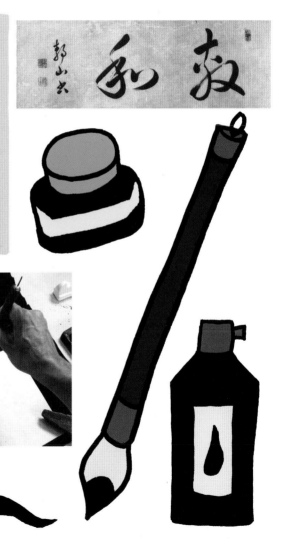

Bunbōgu

STATIONERY

文房具

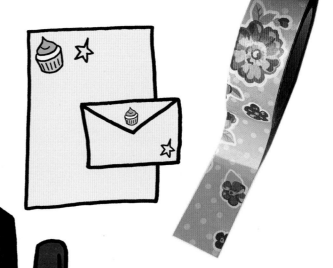

Stationery shopping in Japan is a pure delight! It can be found at department stores, art supply stores, book stores, and specialty shops.

The cutest sets of paper and envelopes, high quality pens, the most adorable stickers, and more can be found when shopping for stationery. Also look for washi tape, which is masking tape made from rice paper with gorgeous designs on it!

Masks

仮面
KAMEN

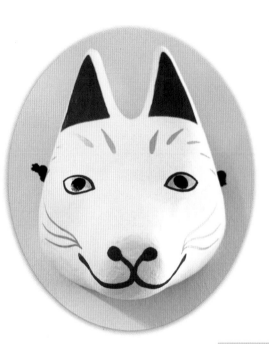

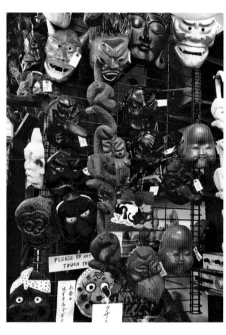

Japan has a long history of the use of masks in ritual and theater, most famously in Noh drama, which is the earliest surviving form of theater originating there.
At festivals it is common to see kitsune fox masks, cheerful masks depicting the round and happy face of the goddess of luck, Otafuku, as well as fearsome oni and tengu masks! Beautiful masks are made by artisans who make each mask unique!

Ukiyo-e

浮世絵

WOODBLOCK PRINTS

Woodblock printing is one of Japan's most famous and revered art forms. Ukiyo-e translates to "pictures of the floating world," referring to the genre during the 17th-19th centuries depicting scenes of nature, actors, wrestlers, folk tales, beautiful women, and more.

Prints are created by carving the image into a wooden block and then using pigments applied to the block to transfer layers of color onto the paper. Images by famed artist Hokusai are still popular today!

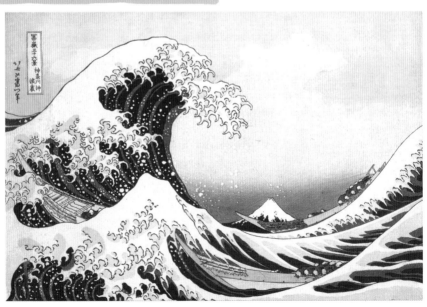

Kazariyama
飾り山

FLOATS

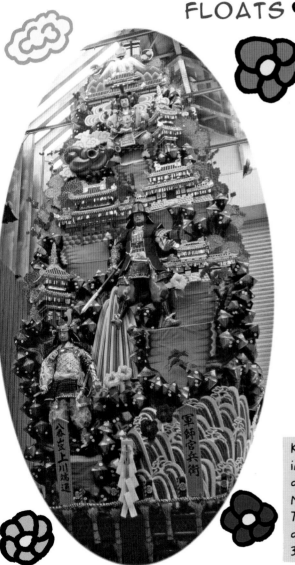

Kazariyama are the huge and impressive festival floats that are part of the Hakata Gion Matsuri in Hakata, Fukuoka. They depict scenes from myths and history, and can be over 30 feet high!

Ningyō

DOLLS

Japan has a long history and relationship with dolls. Paper dolls were used from early times as part of purification and healing rituals. Kokeshi dolls and Hina dolls are examples of traditional doll crafts. Hina dolls are gorgeously detailed dolls of the Heian period's imperial court that are displayed during Hinamatsuri, a festival to pray for the health of young girls. Kokeshi dolls are a craft from northeastern Japan. These wooden handmade dolls consist of just a body and a head, without limbs. They're very charming!

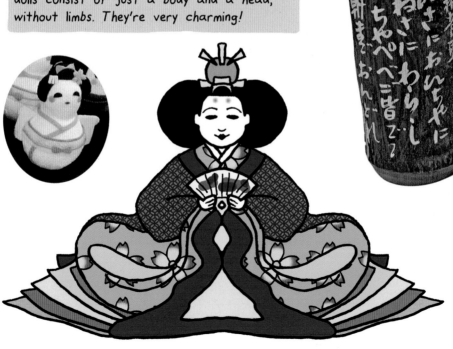

Japan has such an impressive pop culture legacy, one that has influence on what we watch and how we play worldwide!

Many people's first exposure to Japanese culture arrived through video games, via Nintendo game consoles, which were distributed internationally, introducing the world to beloved games and characters!

Godzilla and Ultraman are examples of tokusatsu that achieved global popularity, and along with manga and anime also resulted in the production of many collectible toys.

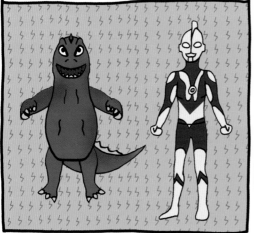

Traditional games like goldfish scooping can still be played at carnivals, while high-tech modern video games are played at home and at game centers!

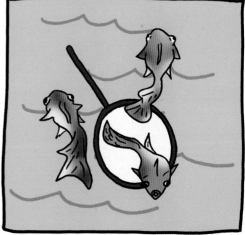

Vintage Toys

ビンテージ ・ トイズ BINTĒJI TOIZU

Vintage toys are so much fun to admire and shop for. They run the gamut from kaiju figures, dolls, antique company mascot figures, tin robots, Kewpies, and more! It's easy to be charmed by their colors and designs. They can be found in manga and hobby stores such as Mandarake and Yellow Submarine, as well as used media shops such as Hobby Off. Nakano Broadway in Tokyo is a popular place to find them as well.

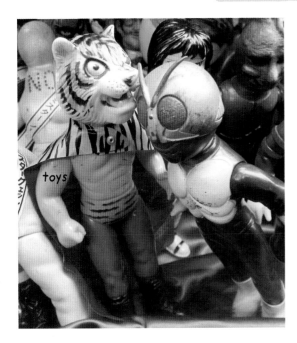

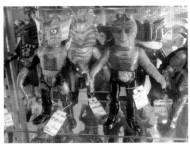

Tokusatsu 特撮
SPECIAL EFFECTS

Tokusatsu films and TV shows are the ones that feature special effects, with the most famed icon being Godzilla, who debuted in 1954. He is an example of the many kaiju (giant monsters) featured in this type of Japanese media.

Kaiju かいじゅう

Gamera is another famous kaiju, he is a giant space turtle who is known as a protector of children, despite his fearsome looks! kaiju films are a lot fun, and a prime example of Japanese pop culture with global appeal!

Sentai 戦隊

COSTUMED HEROES

Sentai is another genre of tokusatsu.
It features costumed heroes or teams
of heroes fighting costumed villains, as
well as fantastical kaiju monsters.
Typically, these shows feature acrobatics,
transformation sequences, exciting vehicles,
and a lot of dramatic posing.
They are a ton of fun!
Power Rangers is one of these types of
shows that achieved huge global success.

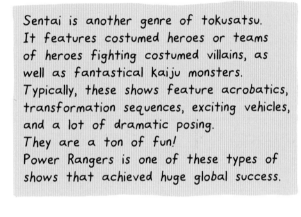

Ultraman is a hugely popular costumed hero
in Japan. He was introduced back in 1966
by Tsuburaya Productions, the studio of
Eiji Tsuburaya, who was a co-creator of
the Godzilla series!
There are many sequels, and Ultraman shows
are still being produced, with toys and
merchandise widely available.

Retro Games

レトロ・ゲーム RETROGĒMU

Nostalgic for old home video games? Retro game stores sell used games and consoles from various eras of video gaming. It's fun to see the original Japanese editions of faves from childhood! Look for them in stores like Super Potato, Retro Game Camp, Book Off, and Hobby Off. There are also bars and cafes themed after old video games and they can feature games, decor, and menus that go along with the whole theme.

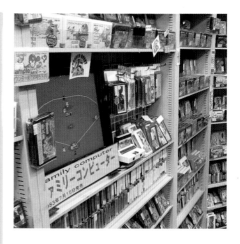

Kingyo-Sukui 金魚すくい

GOLDFISH SCOOPING

At festivals there are numerous games to be played! Kingyo sukui (goldfish scooping) is a popular one. The player wins whatever fish they can scoop into their bowl using a poi, a scooper made of thin washi paper, before the paper breaks. It's a challenge, since the fish move quickly! There are also scooping games for balls and toys with the same basic concept. Other games such as ring toss and target shooting with toy guns can be found at festivals as well.
Festivals are also a good place to find cute masks for kids!

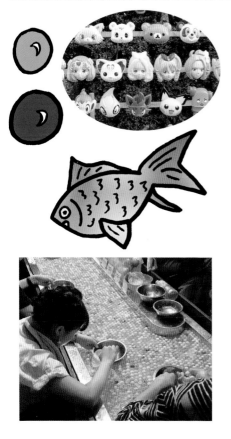

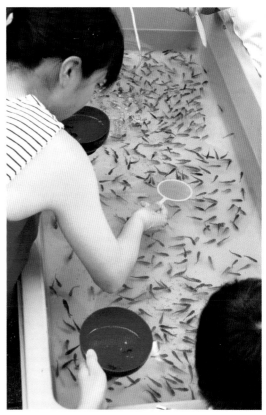

Fune ふね SWAN BOATS

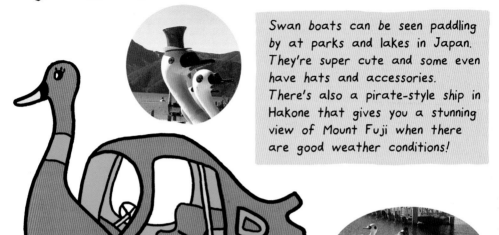

Swan boats can be seen paddling by at parks and lakes in Japan. They're super cute and some even have hats and accessories.
There's also a pirate-style ship in Hakone that gives you a stunning view of Mount Fuji when there are good weather conditions!

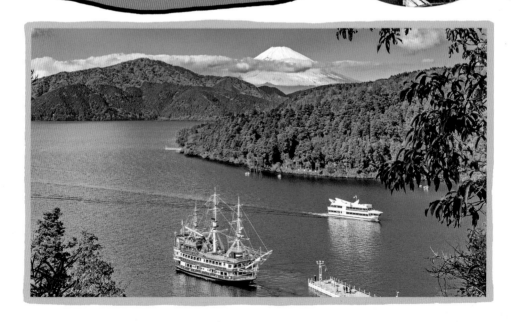

Where to start with fashion in Japan? There are so many beautiful, cute, and stylish looks that can be seen every day!

The beauty and craftsmanship of traditional clothes and textiles are awe-inspiring! While an antique kimono can be a priceless masterpiece, a lovely furoshiki cloth can be purchased for everyday use.

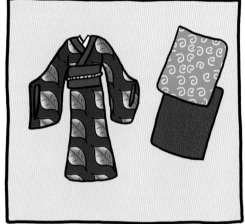

There are also a lot of choices for loungewear and casual fashion. Comfy slippers, stomach warmers, tunics, smocks, face masks, and more, are all available with the most adorable designs!

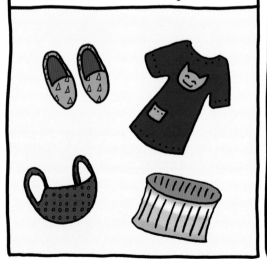

Kawaii fashion is a global phenomenon, and focuses on cuteness above all! It's hard to resist the lure of such cuteness!

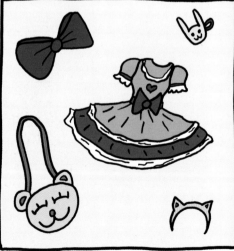

Casual Wear ルーム ウェア

ROOMWEAR

RŪMUU~EA

Casual clothes and roomwear are fun and easy to shop for.
Roomwear refers to clothes to wear when relaxing at home.
This type of loose clothing is available in most sizes, and
it's all about being comfortable and cozy.
Tunics and smocks with cute patterns, as well as slippers, are
in many shops. A unique item to try is a haramaki, which is a
stomach warmer. It's like a tube sweater that goes around the
torso, and keeps the wearer warm! Socks and masks are other
casual everyday items that can be found with different appealing
designs!

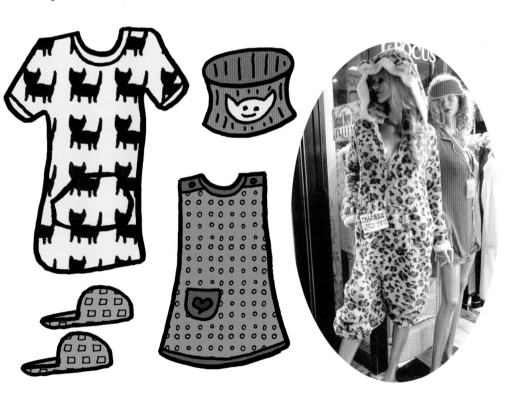

Kimonos 着物

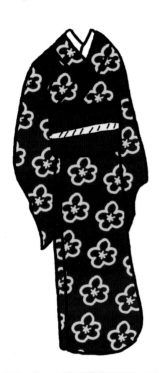

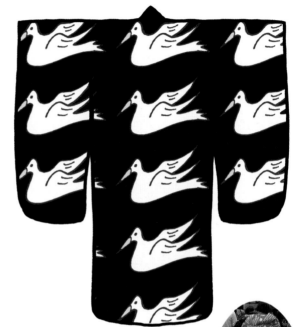

The most iconic Japanese attire, the kimono, is a T-shaped, wrapped, robe-like garment. It's traditionally worn with an obi, which is a decorative sash. Kimono can be worn for formal occasions or everyday wear. There are priceless antique ones, and funky new styles made by young designers. It's more common to see people wearing yukata, which are less formal cotton garments, popular for summer festivals. The lovely fabric and designs of kimono are simply stunning!

Furoshiki 風呂敷

FUROSHIKI AND FABRIC

Furoshiki are decorative cloths that are used in everyday life by being folded into various different shapes for different uses, such as bags or book covers. They are made in many gorgeous fabric patterns, and are popular as gifts and souvenirs! Vintage kimono and obi fabrics are beautiful and often used for crafts. Chirimen are a great example. They are cute figures made out of kimono material. Fabric shopping in Japan is such a fun experience!

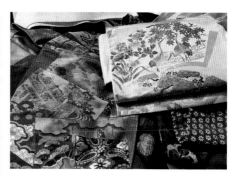

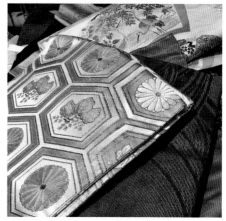

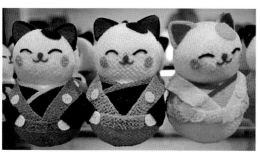

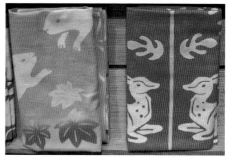

Kawaii

カワイイ
CUTE

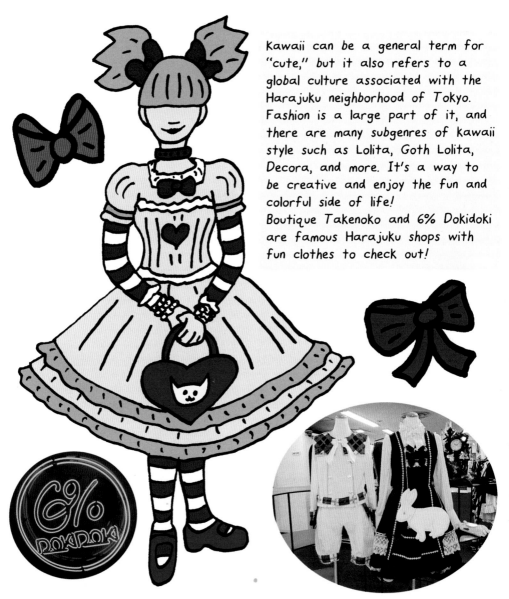

Kawaii can be a general term for "cute," but it also refers to a global culture associated with the Harajuku neighborhood of Tokyo. Fashion is a large part of it, and there are many subgenres of kawaii style such as Lolita, Goth Lolita, Decora, and more. It's a way to be creative and enjoy the fun and colorful side of life!

Boutique Takenoko and 6% Dokidoki are famous Harajuku shops with fun clothes to check out!

Shrines
+
Temples

Many significant historical and cultural sites in Japan are Shinto shrines and Buddhist temples. These are places of worship, so act respectful when visiting!

Shinto is Japan's ancient animistic religion, focused on nature deities. Buddhism was brought from India to Japan about 15 centuries ago. Shrines will have torii gates and temples will have Buddhist statues.

You will see a fountain at the entrance of the shrine or temple. This is for washing your hands before you enter. Inside are icons, statues, and amulets, all with their own unique meanings!

Different shrines and temples feature their own symbols and motifs based on the local history. Amulets and charms can be purchased for good luck and protection.

Torii

鳥居

TORII GATE

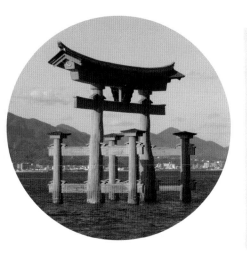

Torii is the gate found at most
Shinto shrine entrances. It marks a
portal into the sacred space.
At Inari shrines there may be many
torii, since they are donated by
local successful businesses to show
gratitude to Inari, deity of success
in industry. When entering through
the torii, make sure not to enter
directly through the center, as that
space is to be reserved for the
deities to enter through.

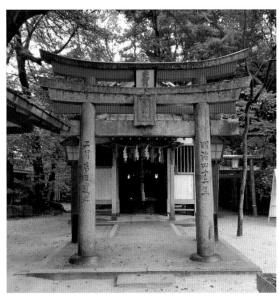

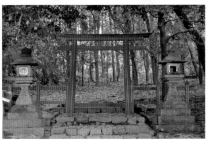

Butsuzō 仏像

BUDDHIST STATUES

Buddhist temples will have statues on the grounds depicting Buddha, and other venerated figures at different levels of enlightenment. Statues of Kannon, goddess of mercy, can be found at Buddhist temples as well. Kamakura is a good place to see both!

There is a giant Buddha at Kotoku-in temple, and a famous Kannon statue at the nearby Hase-Dera temple. It's well worth a day trip to visit such amazing sites!

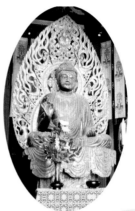

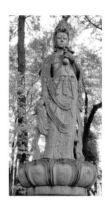

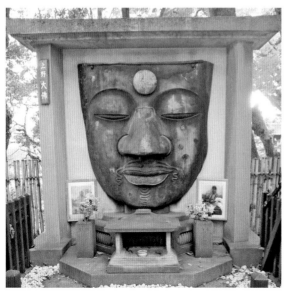

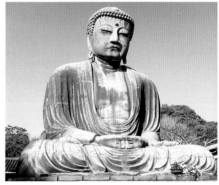

Chōzubachi

RITUAL BASINS

手水鉢

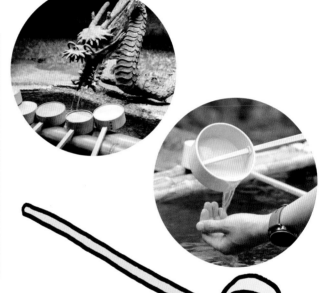

When entering a shrine or temple, it is customary for visitors to wash hands as a symbolic purification before worshipping. There are basins with ladles, usually at the entrance. Often they feature lovely animal fountain designs!

The steps are to fill the ladle, wash your left hand, then the right hand, pour water into your hand and rinse your mouth, then spit the water onto the rocks beside the basin. Finally, rinse the ladle by tipping it upwards vertically, letting the remaining water rinse it.

Omamori 御守 AMULETS

Omamori are protective amulets sold at Shinto shrines and Buddhist temples. They each are meant for specific types of protection, such as easy childbirth or safety while driving. Prayers are written on paper or wood and often sewn into a beautifully decorated silk bag. Omamori usually have a design that is related to the deity or motif the shrine or temple is affiliated with. For instance, Inari shrines would likely have fox designs. They make wonderful gifts!

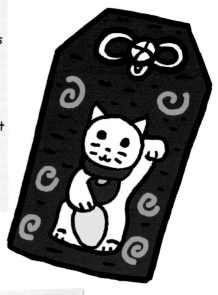

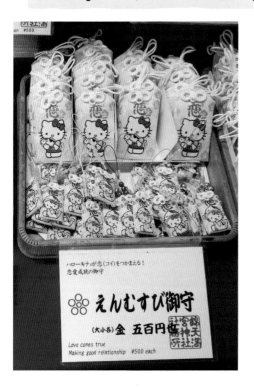

ハローキティが恋(コイ)をつかまえる！
恋愛成就の御守

えんむすび御守

(大小名)金 五百円女

Love comes true
Making good relationship ¥500 each

関運厄除おまもり

尾山神社

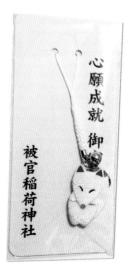

心願成就 御

被官稲荷神社

Ema

絵馬
PRAYER PLAQUES

Ema are wooden plaques found at shrines and temples. Worshippers can purchase a plaque to write their wishes on the back, and then tie to a stand so the deities can receive their prayers. This originated from the tradition of donating horses for good luck. Plaques depicting horses came to symbolically replace the real horses. Eventually, the designs on the plaques varied and now they have all kinds of different visual motifs!

Komainu

狛犬
GUARDIAN
STATUES

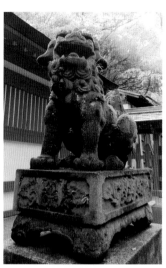

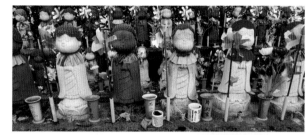

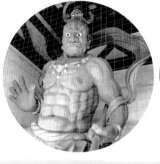 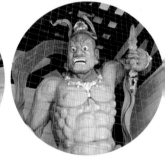

Shrines and temples have various statues that symbolically guard and protect.
Shrines have a pair of komainu lion-dogs, who guard the entrance. Temples can have two intimidating, muscular statues at the entrance called Kongorikishi. In both cases one of the pair has its mouth open and the other closed.
Jizo are another ubiquitous Buddhist icon. These little statues represent the benevolent deity who protects the spirits of children and babies in the afterlife, he also is known to protect travelers.
Jizo are often decorated with bibs, toys, and flower garlands.

Rice is synonymous with Japanese agriculture and cuisine. There, rice-based dishes are a staple and rice also holds great spiritual and cultural significance. Rice even has its own deity - Inari, the fox god!

The most common rice in Japanese cuisine is the short-grain Japonica rice a.k.a. uruchimai. The glutinous mochigome, is used to make mochi. Newly harvested rice is especially favored, people rush to buy it when it's in season!

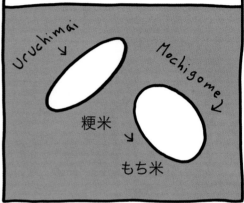

Uruchimai
粳米
Mochigome
もち米

Rice is very versatile, and is the basis of the alcoholic drink sake. Rice flour can be used to make noodles, and even bread or crepes!

This chapter will highlight some of the most popular and iconic rice dishes that can be found in Japan!

Sushi

Sushi is one of the most famous, iconic (and delicious!) Japanese dishes. It typically consists of raw fish or seafood (such as fish eggs or shellfish), rice seasoned with vinegar, and seaweed. Individual sushi pieces over rice are called nigiri, rolls are called maki, a large cone-shaped roll wrapped in seaweed is called temaki. The oval-shaped seaweed wrap with the fish roe or sea urchin on top of the rice layer is called gunkan maki and sushi rice topped with a seasoned egg omelet is called tamago sushi. All styles of sushi are tasty!

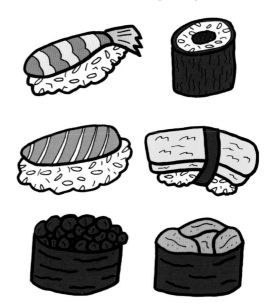

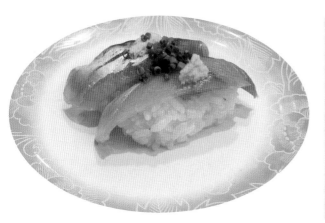

Sushi is easy to find anywhere in Japan and can be crafted by famed chefs at fancy gourmet restaurants, served in small local neighborhood establishments, or even purchased inexpensively from conveyor belts. Beautiful and tasty, sushi is a must-try!

Onigiri

Onigiri (also known as omusubi) are rice balls. A wonderful snack anytime! They consist of seasoned rice and can have many different fillings and toppings. Fish, pickled plum, hard boiled egg, and even teriyaki beef or chicken can be found inside. Many types can be seen in convenience stores, and there are specialty shops that make very fresh and beautiful varieties. Keep an eye out for this tasty, filling, and affordable snack!

Donburi

丼
RICE
BOWL

"Donburi" refers to a meal with a main course topping served over rice, often in a bowl. There are many kinds of donburi such as katsudon (fried pork cutlet), gyudon (simmered beef and onions), unagi don a.k.a. unadon (grilled eel), oyakodon (chicken cooked with eggs), tenpura don AKA tendon (tempura), chirashi don (assorted raw fish over sushi rice) and more!
Donburi make great lunch sets and are quite inexpensive.
For a hearty and satisfying meal, you can't go wrong with donburi!

Curry Rice

CURRY OVER RICE

カレー ライス

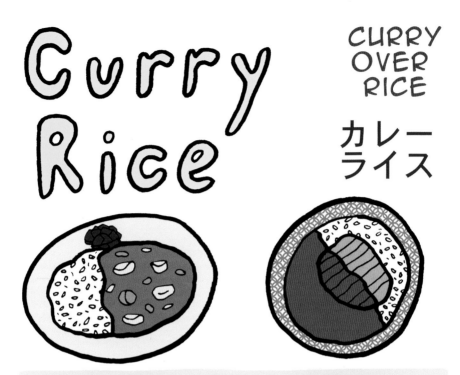

Curry rice is a unique Japanese take on curry stew served over rice. Adapted from British-style curry, which was introduced in the Meiji era, it's hugely popular and a staple of school lunches and home cooked meals. It's very easy to make at home, thanks to curry bricks widely available at Japanese groceries. There are many curry-specific fast food restaurants, and certain neighborhoods in Tokyo (such as Jinbocho and Shimokitazawa) are known for their curry!

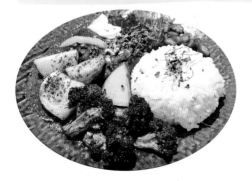

Omurice RICE OMELETTES
オムライス

Omurice is another favorite meal for children. Chicken fried rice, cooked with ketchup, is wrapped in a thin egg omelette and topped with more ketchup! Often the ketchup is used to make cute designs or garnishes around the omelette. Sometimes it's made with Demi Glace (beef-based) sauce instead of ketchup for the garnish. A few restaurants claim to have originated the dish at the turn of the twentieth century, including Renga-tei in Ginza and Hokkyokusei in Osaka. There can be variations on the ingredients, including different meats and vegetables, but chicken is the most common version. Another version involves cooking and placing the omelette atop the rice. If the rice filling is replaced with fried noodles, it's called omusoba. It seems simple to make, but getting the thin egg layer to wrap around the rice without breaking can be tricky. Omurice is popular in South Korea and Taiwan, China too!

Ochazuke

お茶漬け

Ochazuke (also known as Chazuke) is porridge made by pouring green tea over rice mixing with various toppings. Common toppings include pickled plum and salmon. It's usually garnished with flakes of nori seaweed. It's very easy to make at home, especially if you get instant packets available at Japanese grocery stores. Just sprinkle it over rice, and add hot water!

Since the Heian period (794-1185), people in Japan have been combining tea with hot water and rice. Instant packs became available in the 1950s, making it even more popular. It's often eaten as a comfort food to settle the stomach. In restaurants ochazuke is typically eaten at the end of a multi-course meal.

Bento + Set Meals

Bento and set meals are some of my favorite aspects of Japanese cuisine. Having many parts to a meal makes it more fun!

A bento is a boxed meal, often with many compartments to it.
Each bento includes rice, fish or meat, and vegetables, and ideally it should be designed with pleasing colors and composition.

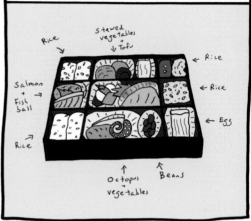

A bento exists in different contexts. It can be a cute home-made meal crafted lovingly for a child, spouse, or sweetheart, or it can be a cheap business lunch purchased at a bento shop or convenience store. A bento can be bought quickly at a train station to be enjoyed on the journey, or it can even be served as a high-end meal made with gourmet seasonal ingredients served in an upscale restaurant.

Set meals are a bit more of a general term, but often referred to as Teishoku. Most restaurants offer an option to add miso and rice servings to your main course, especially during lunch time and at a discount. Or if you are at a ramen restaurant sometimes gyoza or a mini donburi are offered as set options to go with your noodles.

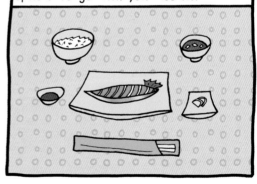

Makunouchi Bento

"BETWEEN ACTS" BENTOS

幕の内弁当

Makunouchi Bento is a popular bento style that typically features rice, often topped with an umeboshi (pickled plum) or sesame seeds, and various other components often including fish, egg, meat, and vegetables. The name originates from the Edo period when this type of bento was served between acts during intermission at performances of Noh and Kabuki plays. The plays were known to be quite long, so having a conveniently packed meal during intermission was a great innovation. The name eventually went on to refer to bentos commonly sold at department stores, convenience stores and restaurants, and can also refer to those sold at train stations (a.k.a. Ekiben).

Makunouchi Bento typically will have a larger variety of items than a basic bento and cost more. The variety makes it especially exciting!

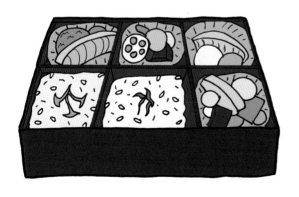
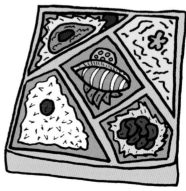

Ekiben

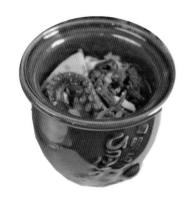

Ekiben is a bento that can be purchased at train stations and on trains to enjoy during the journey. Often, each bento is unique to the regional location of the train station and features culinary specialties of the area. It's a lot of fun to browse the many options, so make sure to arrive at the station early to make your selection! Tokyo Station has a shop called Ekibenya Matsuri that sells bento from all over Japan in one place. Some include interesting ceramics and packaging that make great souvenirs! They're beautiful to look at and there are options for everyone to enjoy. Keep an eye out for train-shaped bentos for kids!

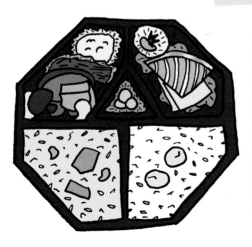

Teishoku

定食

Teishoku is the classic style of Japanese set meal with all of the dishes served together. It's based on the concept of ichiju-issai (one soup, one side) meals that were historically offered at Zen temples. Those meals would include soup, rice, a main dish, and pickles. This style of meal has spread nationwide and is the basis of the usual meal sets served in present-day restaurants and is also commonplace in home cooking. Restaurants often serve several options in a set menu, it's nice to have so many choices!

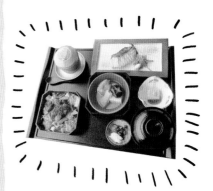

Kyaraben キャラ弁

CHARACTER BENTOS

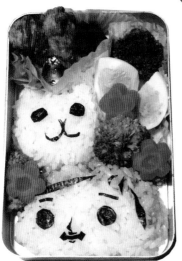

The most fun of all bento, a kyaraben features food and rice shaped into cute animals or cartoon characters that are especially appealing to kids. Parents create kyaraben making special designs that help encourage children to eat up all of their healthy homemade lunches.

Creative shapes are arranged with rice, while cheese slices, nori seaweed sheets, and ham slices are cut up to depict facial expressions. Cute and tasty!

Osechi Ryori

お節料理

NEW YEAR'S MEAL BOX

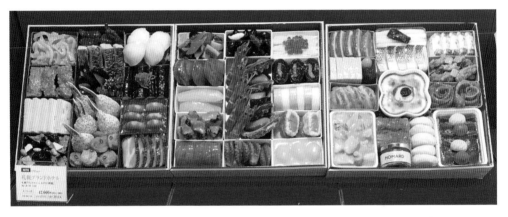

Osechi Ryori is the traditional boxed set of delicacies enjoyed during the New Year holiday. Since it's a time to relax and not cook, the foods are able to last over a few days and are ready to eat. And many of them have traditional meanings to bring an auspicious new year. For instance, the shrimp, even with its bent back, symbolizes long life. Sweet rolled egg omelet represents gaining knowledge. Taro root symbolizes fertility, and so on. The dishes are stacked in special boxes called jubako to represent piling up good fortune!

Kaiseki

会席料理

Kaiseki ryori is a traditional multi-course meal. It can be found at restaurants that specialize in this cuisine and at traditonal Japanese-style inns. It originated from meals served during tea ceremonies, and evolved into the ultimate in elegant luxury dining. The dishes are served one at a time. The food has a seasonal focus and is artfully prepared and displayed on beautiful and unique tableware. It's customary for the meal to include soup, sashimi, a boiled dish, a grilled dish, a deep-fried dish, a pickled dish, rice, and dessert. It's a wonderful experience!

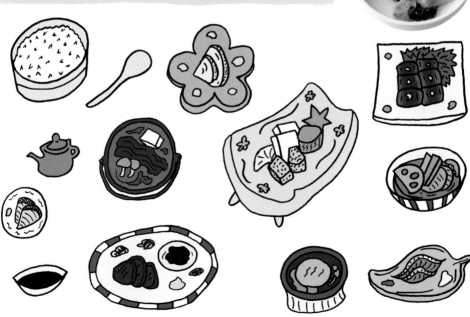

Noodles! One of my favorite dishes to eat in Japan! Just the sheer variety of high quality noodles that can be enjoyed is incredible. Hot, cold, thick, thin, straight, curly, in soup, fried, dipped, plain, or with toppings, in all kinds of ways, noodles always satisfy!

One fun fact about noodles in Japan: A common culture shock for tourists is that it's acceptable in Japan to slurp loudly when eating the noodles. It shows appreciation to the chef!

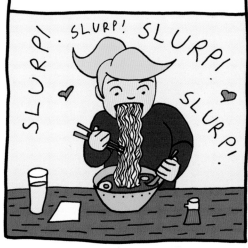

Perhaps Japan's most iconic noodle, -ramen- originated in China and it's believed that it was introduced by Chinese immigrants circa 1859. Around 1945 ramen yatai (stalls) became popular nationwide.

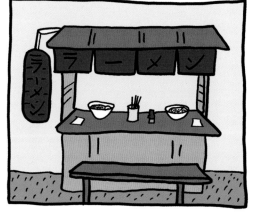

Instant ramen was invented by Momofuku Ando of Nissin Foods and launched in 1958, and instant cup noodles were introduced in 1971. They became common worldwide. Let's have some right now!

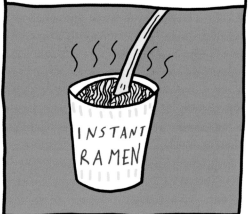

Ramen

ラーメン

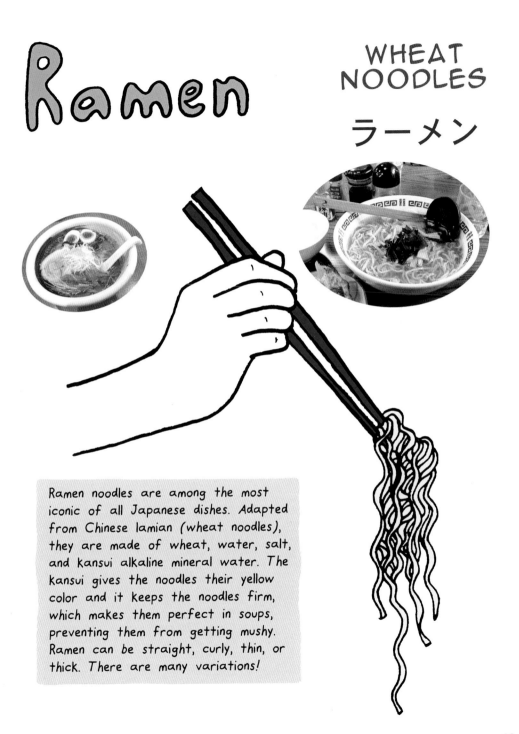

Ramen noodles are among the most iconic of all Japanese dishes. Adapted from Chinese lamian (wheat noodles), they are made of wheat, water, salt, and kansui alkaline mineral water. The kansui gives the noodles their yellow color and it keeps the noodles firm, which makes them perfect in soups, preventing them from getting mushy. Ramen can be straight, curly, thin, or thick. There are many variations!

WHAT MAKES A BOWL OF RAMEN?

It starts with a broth! Commonly made from dashi (fish and seaweed), chicken, or pork, but there are many variations!

Next is the Tare (flavor), the most common being based on shio (salt), miso (soybean paste), or shoyu (soy sauce).

Then of course the noodles! These can vary in thickness and texture depending on the style of ramen.

Toppings finish it off! Chashu pork, nori (seaweed), menma (bamboo shoots), scallions, corn, fish cake, even butter can be options! New toppings are always being introduced!

Udon

THICK WHEAT NOODLES
うどん

Udon are thick white wheat noodles. Often they are served in a soup with mentsuyu broth made of mirin, sake, soy sauce, and bonito fish flakes. Tempura is a popular topping with udon!

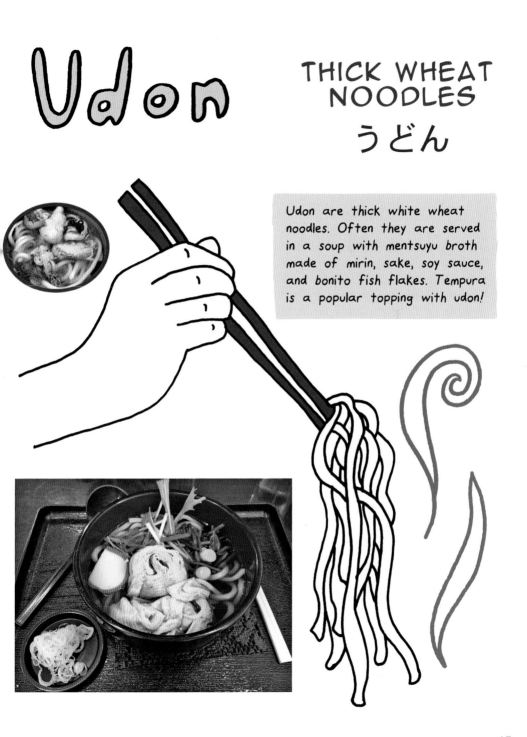

Soba

BUCKWHEAT NOODLES
蕎麦

Soba noodles are straight and thin and made with buckwheat. They are most commonly enjoyed cold and dipped in broth (called mentsuyu), made of mirin, sake, soy sauce, and bonito. They are often served in a hot soup too (also made with mentsuyu) with toppings. Very fun to slurp!

UDON AND SOBA BASICS

MENTSUYU

Udon and soba are almost always served with mentsuyu. Made of bonito fish flakes, sake, mirin, and soy sauce, it is either served cold as a dipping sauce or as the broth in a bowl of hot noodle soup. Wasabi, scallions, grated daikon, and nori are often served as condiments with the cold noodles.

TANUKI UDON OR SOBA

Tanuki refers to a topping of small bits of crunchy fried tempura batter and is named after the famed raccoon dog!

KITSUNE UDON OR SOBA

Kitsune refers to a topping of fried tofu. This is said to be a favorite food of foxes, hence the name!

TEMPURA

Tempura is commonly served as part of sets along with cold soba or udon, or as a topping for hot bowls of the noodles in soup.

Yakisoba

FRIED NOODLES 焼きそば

Yakisoba is a dish of stir-fried wheat noodles, typically including pork, cabbage, and other vegetables such as carrots and onion. It is often garnished with red pickled ginger, mayonnaise, bonito flakes, and aonori seaweed powder. It is said to have originated circa 1950. At that time flour was expensive, so extra cabbage was used when noodles were scarce. Since the cabbage's water content dilutes the taste of soy sauce, Worcestershire sauce is used to flavor it. Yakisoba is a popular dish with kids. It's also commonly sold at stands during festivals. Note it is not made of buckwheat, like soba noodles are.

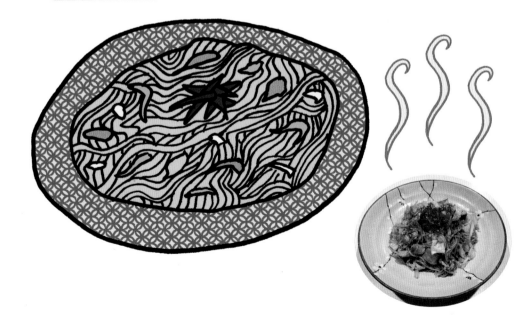

Somen

THIN WHEAT NOODLES

そうめん

Somen are extra thin wheat noodles, they are a common dish in the summer, served cold with dipping sauce. A fun way to eat them is called nagashi-somen. A waterslide is fashioned from a length of bamboo, and bundles of the noodles are sent floating down the slide in cold water! Diners grab the noodles with chopsticks as they slide by. They then dip them in sauce and eat them. A unique way to enjoy noodles for sure!

TsuKemen
DIPPING RAMEN つけめん

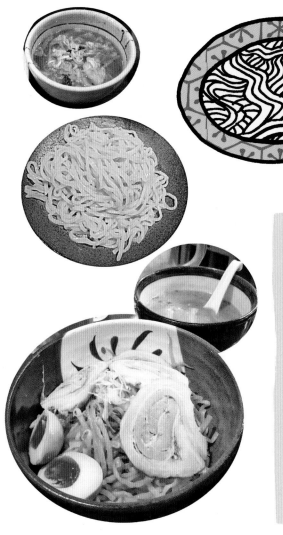

Tsukemen is a dish of cold ramen noodles served with warm broth to dip them in, and can be served with ramen toppings such as pork slices and egg. The soup has a more intense flavor than traditional ramen soup.

It's a great way to eat ramen when the weather is too hot out.

Tsukemen is a more recently developed style of ramen, said to have been originated in 1961. There are always new styles and innovations in the world of ramen!

Sweets + Snacks

Japan is famed for its sweets and snacks. Even just looking for a snack at the convenience store, there are so many options it's almost impossible to choose sometimes!

Japan has many types of artisanally-crafted traditional snacks with a long history like wagashi, mochi, and senbei rice crackers.

Popular foods from all around the world have been tweaked with Japanese innovations, including ice cream, pudding, castella, mont blanc pastries and pancakes.

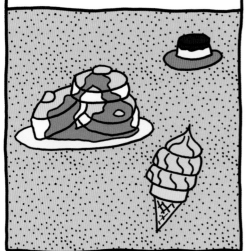

Seasonal themes, regional influences, and limited-edition flavors are very popular and result in huge varieties in flavor for products such as Kit Kat bars and Jagarico potato snacks!

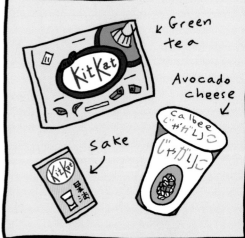

Green tea

Avocado cheese

Sake

Wagashi 和菓子

TRADITIONAL CONFECTIONS

Wagashi are traditional Japanese confections. From tea ceremony sweets to everyday treats, they come in all kinds of shapes and colors. Often they are themed to the season and made with mochi and red bean paste. They have a long history and truly can be tiny works of art!

Anmitsu あんみつ

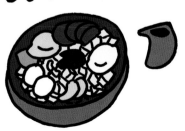

Anmitsu is a traditional dessert from as far back as the Meiji era! It's a bowl of clear agar jelly cubes topped with various items that can include mochi, ice cream, red beans, and fruit. Often that concoction is dressed with a sweet syrup of black or white sugar.

Crepes クレープ
KRĒPU

In Japan, the thin French pancakes, crepes, are a very popular treat, but Japanese crepes have their own unique style. On the streets of Tokyo, crepe stands offer a huge variety of sweet and savory fillings. Sometimes with even a full slice of cake or pudding on top! Of course, you can never go wrong with classic toppings like whipped cream, fruit, and chocolate sauce.

Pudding
プリン PURIN

Flan-style pudding, a.k.a. crème caramel, is very popular in Japan, and several varieties can be found in any convenience store and also on menus at most cafes, bakeries, and restaurants. There are many flavor variations such as matcha, chocolate, pumpkin, strawberry, and more. It's a rich and delicious treat!

Honey Toast

ハニートースト

HANĪTŌSUTO

Honey Toast, also known as Brick Toast or Shibuya Toast, can be found at the karaoke chain Pasela, and at some cafes. It's an entire bread loaf with the center scooped out, cubed and baked with honey, then the cubes are placed back inside the toasted loaf. It's decadently topped with ice cream, whipped cream, fruit, cookies, and syrup. Beyond just toast, this is a big dessert that a group can share!

Character Breads

キャラパン

KYARAKUTĀPAN

Character Breads are cute breads shaped like funny animals or cartoon characters. They can be found at many bakeries, and are just a lot of fun to look at and eat!

Parfaits

パフェ

PAFE

Parfaits glow like jewels in cafe windows on the city streets of Japan. They are over-the-top, colorful, gorgeous, and just fun to look at! Ingredients like ice cream, red beans, fruit, cookies, syrup, mochi, whipped cream, and more can be found in these creations.

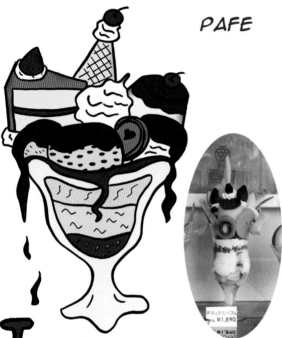

Ice Cream

ソフトクリーム

SOFUTOKURĪMU

Soft serve ice cream is beloved in Japan and almost every tourist destination has its own signature flavor available. Look for the many interesting flavors such as purple potato, fish, pickled plum, and more traditional flavors like green tea, red bean, and black sesame.

kitKats
キットカット

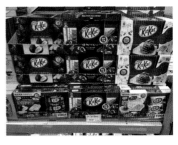

Ah, Kit Kats! Recently they have become a quintessential souvenir choice. In Japan, Kit Kat bars are available in a huge variety of flavors, and new limited-edition seasonal and regional ones are introduced all the time! The gorgeously-designed packaging and unique flavors make them a favorite for tourists to try out. Sake, purple potato, green tea, apple, orange, wasabi, passion fruit, and banana are just a few of the many flavors of Kit Kat Japan has produced. Check out shops at major train stations and airports for the largest flavor variety.

Jagarico じゃがりこ

Jagarico are delicious potato snack sticks that come in canisters and can be found at most convenience stores. These also are produced in limited-edition seasonal and regional flavors like fish, avocado cheese, fried chicken, seaweed, ume (pickled plum), yuzu citrus, and more!

Obanyaki 大判焼き

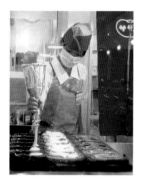

Obanyaki, Dorayaki, Imagawayaki, (and other names) refer to sweets made with batter, baked in special pans. They include delicious fillings such as red beans, custard, and whipped creams in various flavors. Popular as a street food and in department stores, they taste the best when fresh and piping hot!

たいやき

Taiyaki

Taiyaki fall into the obanyaki category of sweets, but these are baked in a fish-shaped mold and have their own special charm! Tai fish is a Red Sea Bream that symbolizes good luck. This sweet can be traced back to the Edo period and evolved from Imagawayaki, which have a round shape.

Konpeito コンペイトー

Konpeito is tiny hard candy in the shape of colorful spiky balls. It was introduced to Japan by Portugese traders in the 16th century. It can be found at souvenir shops, candy stores, and supermarkets.

Candied Fruit

フルーツ あめ

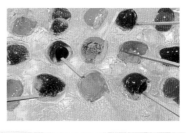

FURŪTSUAME

In Japan, they not only have candied apples, they make candied fruits, including grapes, berries, tiny apples, and citrus. These can be found sold at stands during festivals. Another fruit treat is mizuame, fruit in a sticky, clear layer of syrup, displayed on a bed of ice!

Amezaiku 飴細工

Amezaiku is the art of candy sculpture.
An artist sculpts and cuts pliable colored mizuame (sticky sugary liquid) into shapes which can then be painted. The craft has been used since the Heian Period for temple offerings. Typically they are formed into animal shapes. Amezaiku stands can often be found at festivals.

Soufflé Pancakes

SUFUREPANKĒKI スフレパンケーキ

Soufflé Pancake is a heavenly, fluffy version of a pancake that is available at various specialty pancake restaurants. They are puffy, jiggly, soft, and very photogenic, as well as tasty. Often there are long waits for them, so try to get a reservation in advance!

High tech

Right after I pass through customs entering Japan, the first things I take notice of (and make use of) are machines!

High tech toilets, ATMs, and vending machines are typically my first encounters at the start of a trip.

Of course, the toilets make the most immediate impression!

So many buttons!

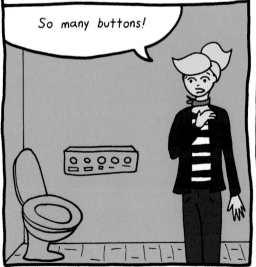

Those are just a few examples. There is so much more to machines in Japan, new innovations are being made constantly!

PRINT CLUB Machines

プリクラ
PURIKURA

Print Club (popularly abbreviated to Purikura) machines have been around since the 1990s, and are still quite popular, especially with teen girls. It's a spin on the basic photo booth concept. You pay a fee and pose for photos, solo or with your friends. What makes it different is Purikura machines can turn out photos of an ultra-airbrushed supermodel version of yourself, and in addition to just looking more glamorous, there are options to add writing, art, cute animal ears, and various other methods to mark up the photo in fun ways. It prints out a sheet of photo stickers which you can cut up and divide with friends. The photos can often also be downloaded via a link or app provided.

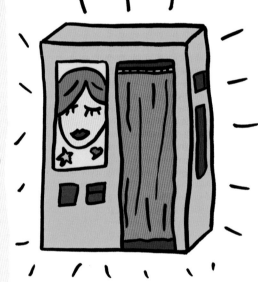

BEFORE

AFTER

Vending Machines

自動販売機
JIDOHANBAIKI

Vending machines (Jidohanbaiki) have a long history in Japan, and the country has the most machines per capita (roughly 1 for every 23 residents)!

There are some very noticeable differences between Japanese vending machines and American ones. For instance they sell hot and cold drinks. The red buttons indicate hot drinks, and the blue buttons indicate cold. Also, they may carry hot soup such as miso soup, onion consomme, corn potage, or pumpkin soup. I am really enamored with this feature of Japanese vending machines!

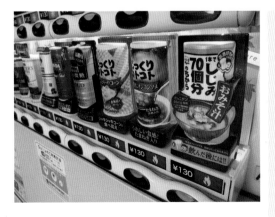

Vending machines are not just for drinks, they can sell just about anything you can think of. Souvenirs, eggs, bananas, readymade burgers, electronics, alcoholic beverages, and more can be found in Japan's vending machines.

You can even use IC Cards (train passes, such as Suica or Pasmo) to pay instead of using cash.

Video Games

ビデオー ゲームズ

One of Japan's largest pop culture influences worldwide is video games. Super Mario Bros., Pac-Man, The Legend of Zelda, Donkey Kong, Street Fighter, Sonic the Hedgehog, Kirby, and of course, Pokémon are iconic games! All of these beloved games, and many more, originated in Japan. Young gamers worldwide are already quite versed in Japanese pop culture based on the games alone.

BIDEŌGĒMUZU

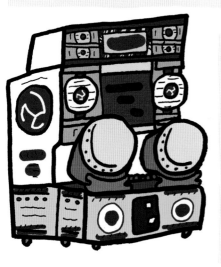

However, while formerly ubiquitous arcades have been dying out in the US (though you can still see old favorites in retro game bars for adults), in Japanese cities, it's easy to find huge game centers, multilevel arcades with all types of video games to entertain. Crane games known as UFO Catchers are also plentiful. Just like similar games in the US, the object is to win a prize by grabbing it with a mechanical claw and dropping it into the chute. The prize is usually a stuffed animal, but they can vary. Look for unique games, like this one modeled after taiko drums!

High Tech Toilets

WASHLET

ウォシュレット

Among Japan's most notorious technical innovations are high tech toilets! They are commonly referred to as Washlet, the trademarked brand of manufacturer Toto. Introduced in 1980 these wonders are ubiquitous in public restrooms at department stores, hotels, airports, restaurants, and homes.

Not everywhere has them, but you'll know one when you see it! There is a control panel with buttons, and some even have a motion sensor lid that pops up when you enter the room. The panel has buttons to control the water flow of the bidet, sound effects, temperature, and more!

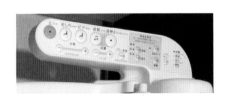

Gashapon

CAPSULE TOYS

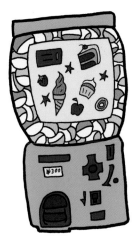

ガシャポン

Gashapon (a.k.a. Gachapon) are the toys dispensed by small coin-operated vending machines. The name is an onomatopoeia of the sound the capsule makes as it is dispensed through the machine's chute. These machines can be found on many street corners and lined up in rows upon rows at toy stores, department stores, and even train stations and airports! The capsules are inexpensive and updated regularly, making them a collector's delight! The toys inside the capsules have a huge range, and often have quirky and cute designs.

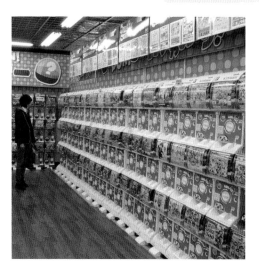

Robots

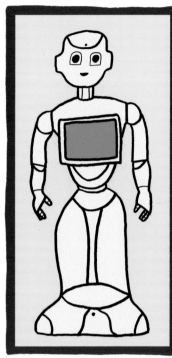

Robots are a huge part of Japan's pop culture history, featured prominently in manga and anime. Now helpful real-life robots are becoming more common at places like train stations and restaurants, ready to assist you in getting your tickets and give you directions. Huge iconic robot statues are on display, such as the Tetsujin 28 statue in Kobe and the Unicorn Gundam in Tokyo in Odaiba.
Check them out!

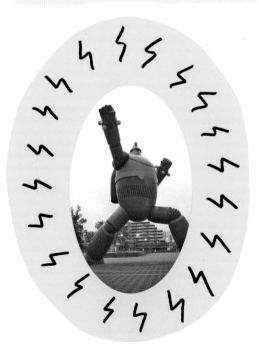

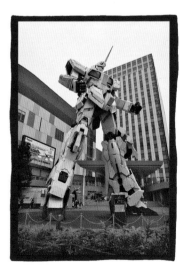

In Japan, you'll notice many types of creatures, both real and mythical. You may already be familiar with some...

...such as my beloved Maneki Neko!

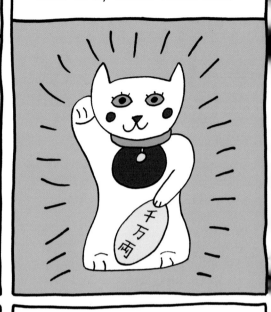

Others, such as kitsune, deer, monkeys, and tanuki, are real-life animals that also play roles in Japanese culture.

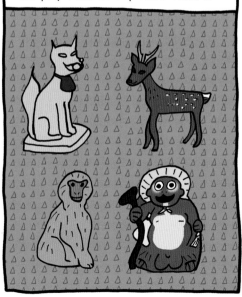

Meanwhile, kappa, oni, and tengu are totally mythical and unique creatures. Let's learn all about them!

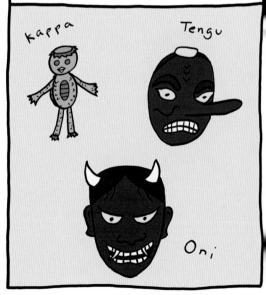

Kappa

Tengu

Oni

Maneki Neko

まねき ねこ

LUCKY CAT

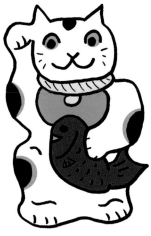

Maneki Neko are lucky cats that invite good fortune and prosperity. They beckon money and luck with their raised paws. With the right paw raised, the cat will invite money and good luck in business. The left paw raised invites people or customers. Both paws raised will invite protection. These cute cats statues can be seen everywhere, especially at restaurants! A great place to see many of them in the Tokyo area is Gotokuji Temple in Setagaya. That is where the most widely-accepted legend of Maneki Neko's origin took place. It is said that in the 17th century, a white cat belonging to the temple beckoned a traveling samurai lord away from a tree, which was then struck by lightning. The grateful lord became a patron of the struggling temple. Later, when the cat passed away, the temple made a statue in his memory. The town of Seto in Aichi Perfecture has an annual Maneki Neko festival and a museum is dedicated to them!

Tanuki たぬき
RACOON DOG

Tanuki, also known as racoon dogs, are noctournal animals that are found in the wild. Tanuki are also popular creatures in folklore. They are known to be jolly pranksters with shapeshifting abilities and comically large testicles as well!
Tanuki statues can be commonly seen in doorways and gardens.

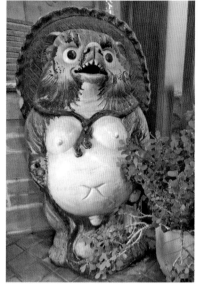

A typical tanuki statue depicts it with a big smile and wearing a straw hat, holding a bottle of sake and a promissory note.
Tanuki are honored at Chingodo Shrine near Tokyo's Sensoji Temple.
There are even tanuki-style Udon and Soba dishes! They have a topping of fried tempura batter flakes.

Kappa

河童
RIVER CHILD

Kappa are amphibious, supernatural creatures. They can be found in rivers, swamps, and other bodies of water. When angered, they are known to be vicious and drown humans. They are also know to love cucumbers, hence the name for kappa maki (cucumber sushi rolls).

Kappa can be found around Tokyo's kitchenware street, Kappabashi-dogu-gai. There, many icons and signs depicting kappa can be seen. This golden Kappa Kawataro statue is a great example. Kappabashi is also a great place to shop for cooking supplies and plastic food models!

93

Oni OGRE 鬼

Oni are supernatural, ogre-like, demon-like creatures. They are known to spread chaos and disease. It's believed that oni had been humans so incredibly wicked that they transformed into oni. There are protective customs that incorporate oni, such as onigawara roof tiles being placed on buildings to ward off harmful spirits and bad luck. On Setsubun, a festival celebrated in February, it's customary for families to throw roasted soybeans at a member who wears an oni mask, chasing away bad spirits from the household.

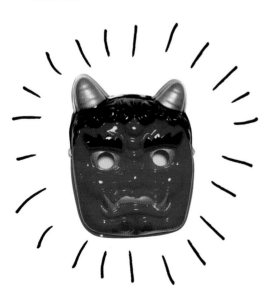

MonKey

猿
SARU

The macaque monkey is found in various areas of Japan. They are quite intelligent and like to bathe in hot springs. They can be seen bathing at Jigokudani Monkey Park in Yamanouchi, Nagano Prefecture. When in an area with monkeys around, keep a very close eye on your bags! They are notorious for stealing food and can be very aggressive.

There's a famous wood carving featuring monkeys at Toshogu Shrine in Nikko. Visitors can see local monkeys in the area too!

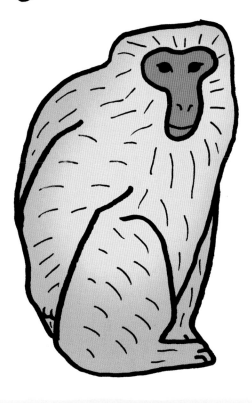

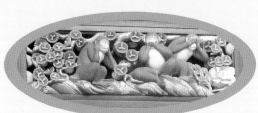

Famed carving of monkeys at Toshogu Shrine in Nikko.

Tengu

天狗

MOUNTAIN SPIRIT

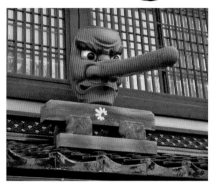

Tengu are fearsome legendary spirits of the mountains and forests. There are two types of tengu: karasu-tengu (with bird-like features) and hanadaka-tengu (long-nosed). Tengu are large and powerful with massive wings. They are known to be boastful tricksters and are very skilled in martial arts.

Tengu are also known to guard sacred mountains. A great place to see tengu is Mount Takao, which is under an hour from Tokyo by train. There, Yakuoin temple has impressive statues as well as other icons and talismans depicting both karasu-tengu and hanadaka-tengu.

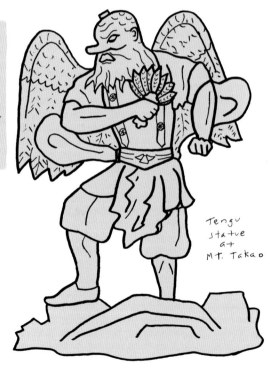

Tengu statue at Mt. Takao

Deer SHIKA 鹿

Sika deer are lovely spotted deer that can be seen in locations such as Nara Park and the island of Miyajima.
They are believed to be messengers to Shinto deities.

Thunder god Takemikazuchi, enshrined in Nara, is said to have appeared riding a white deer. Therefore, deer of the surrounding forest were decreed sacred.

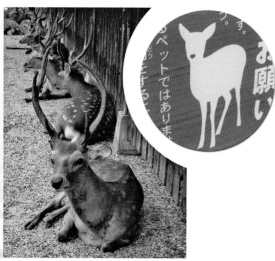

It can be fun to watch the deer strolling through market streets among the people.
In Nara Park, vendors sell rice crackers for visitors to feed the deer. In Miyajima, feeding them is prohibited.
While the deer are beautiful and so majestic, they can be quite aggressive, and are always looking for food, so take care!

Kitsune 狐

FOX

Kitsune can refer to a regular fox, but in Japan kitsune can also refer to folklore foxes who are tricksters and shapeshifters. There are many tales of them fooling humans, but there are also tales of them being faithful companions and even spouses to humans.

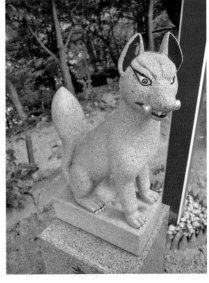

Kitsune have a close association with the Shinto deity Inari, and serve as messengers to the spirit. Inari shrines are seen all over Japan, along with the statues which attend each shrine. Kitsune are believed to like tofu, hence tofu offerings are made at these shrines. Inari-style also refers to udon and soba dishes with fried tofu as the topping!

One of the joys of traveling is seeing how everyday surroundings differ from your environment at home.

If you pay attention while walking down the street in any town in Japan, many details will stand out and, in some cases, amaze you.

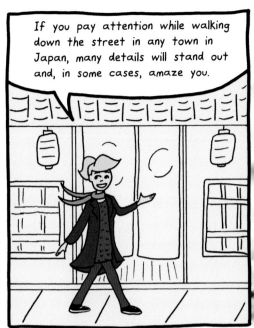

There are the obvious differences such as lanterns and police boxes.
But if you make an effort to observe familiar everyday things...

KOBAN

...like manholes, roofs, and even the lights on top of taxis, you will be rewarded with a variety of unique design elements!

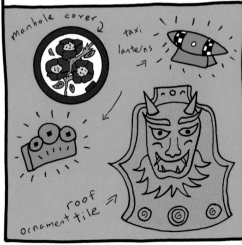

manhole cover

taxi lanterns

roof ornament tile

Manhole Covers

MANHŌRU
NO FUTA

マンホールの蓋

When visiting Japan, look down! You might find a manhole cover
with an interesting design. Different areas have different designs,
many of them gorgeous!
In 1985 civil servant Yasutake Kameda came up with the idea
of artistic manhole cover designs to garner local support for the
modernization of the sewer system projects. Since then almost 6000
artistic manhole covers have been created!

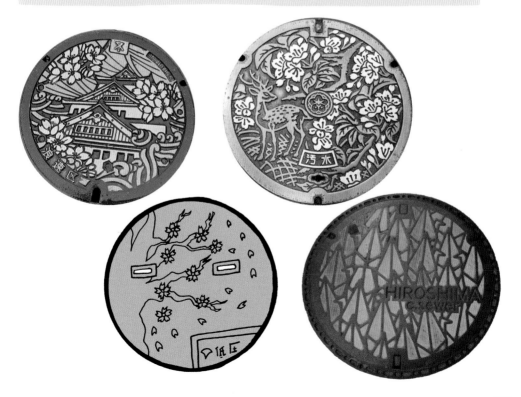

Lanterns 灯籠

TORO AND CHOCHIN

Chochin are paper lanterns, such as those seen outside of restaurants. Often they are red. Toro are the lanterns made of wood, metal, or stone. They can be seen at temples, shrines, and in gardens.

Festivals are perfect occasions to see many paper lanterns on display. During November's Tori-no-ichi festival Tokyo's Hanazono shrine has many fabulous lanterns.

In the springtime, pink lanterns illuminate the cherry trees along the Meguro River at night. It's a must see! Local businesses that sponsor festivals will have their names written on the lanterns.

Traditionally during Obon, the August festival to honor spirits of ancestors, families hang paper lanterns outside their houses to welcome their ancestors' spirits home.

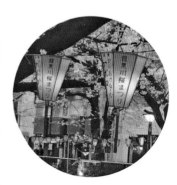

Taxi Lanterns

タクシーあんどん
TAKUSHIANDON

When a taxi drives by, take a closer look! Each taxi has a lantern with its company logo perched on the roof. The logos themselves have many different colors and designs. The variety may surprise you!

TAXI TIP! If a taxi is vacant it will display the red sign 空車 (kuusha) which means empty car, meaning it's available to hail. An occupied taxi will show the green sign 賃走 (chinso) which means it is currently running a fare, and it is not available.

Koban

POLICE BOXES
交番

Koban are police boxes. These are small neighborhood police stations. Some are just the size of a kiosk or a little hut. The fascinating thing is, they have unique building designs, some of which can be really unusual! Often, they will have the word "koban" on them and have a gold star emblem. And of course, at least one police officer can usually be seen on duty at each koban. Koban can be used to get directions, look for lost items, and of course, to report crime.

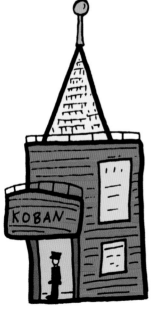

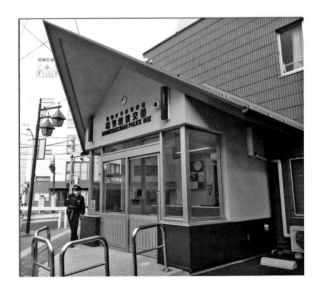

Alleys

路地
ROJI

It's great fun to explore hidden alleys in the cities of Japan! Pay attention as you walk down the street; some of them are so narrow, they're very easy to miss. Alleys often have little bars, shops, and restaurants. If you're lucky you may find a tiny hidden shrine! The retro atmosphere of an alley lit with lanterns is irresistibly charming! Alleys lined with bars and izakaya are referred to as yokocho. Many of the yokocho have historically emerged from post-World War II black market areas. A real sense of history can be felt while enjoying drinks in these spots!

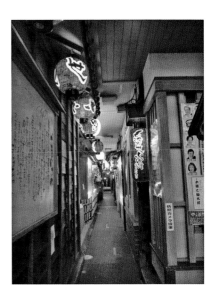

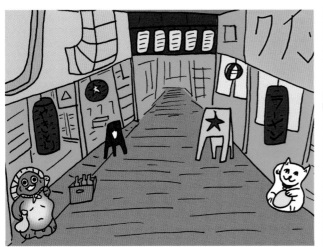

FAMOUS ALLEYS

Omoide Yokocho
(aka Piss Alley)
in Shinjuku

Golden Gai in Shinjuku

Ameyoko shopping
street in Ueno

Ramen Yokocho
in Sapporo

Onigawara 鬼瓦

OGRE ROOF TILES

Onigawara are decorative roof tiles that feature the faces of oni, animals, and mythical creatures. They are often seen on castles, temples, and traditional architecture. This is where paying attention to detail really makes a difference, so make sure to look up when approaching a traditional-looking building, or you might miss out on these unique designs!

Another roof decoration that can be found in Japan is Shachihoko. This mythical sea creature can be seen guarding castle roofs, temple gates, and samurai houses from the Edo period. Also known as Shachi, they were known to protect against fire. A Shachihikowill have a fierce tiger-like head on the body of a carp. Typically, it will be gold and it is a gorgeous detail to observe when looking at a roof in Japan.

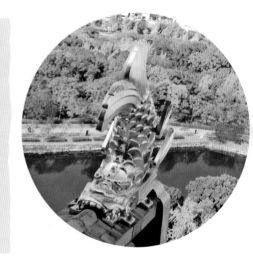

The streets of Japan's cities dazzle with so many amazing signs! Bold and charming design elements can be seen everywhere.

Safety, caution, and manners signs that can be seen in transit and on the streets feature adorable design motifs and cartoon characters, such as this subway door caution sign.

Japan has amazing restaurant signage! Giant animated sea creatures and even mythical dragons can be seen advertising to diners! They float overhead, brightly tempting pedestrians into eateries!

Restaurant windows glisten with mouth-watering and realistic plastic models of food, making it easy to point an order from the street. Called sampuru, they can be purchased at specialty shops!

Giant Beasts

大 動物
DAI DŌBUTSU

Signs that feature eye-popping, huge animals, can be seen in Japan's cities, especially Osaka, where signage is over-the-top! There you can find crabs, squid, octopi, and other creatures, looming cheerfully overhead!

Dragons

竜

RYUU AND BILLIKEN

In addition to huge animals, dragons and other unique statues can be found advertising businesses on the streets! The golden iconic figure of Billiken is an Osaka symbol with an interesting origin. He was created as a charm doll by American illustrator Florence Pretz and patented in 1908. Various Billiken figures can be found in the Shinsekai district.

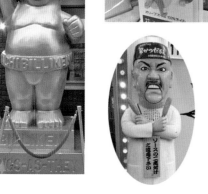

Manners

MANNERS AND WARNINGS

Everyday signs posted on the streets and subways reflect a bright and whimsical design sense that makes walking down the block just a little more interesting!

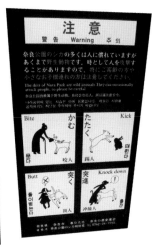

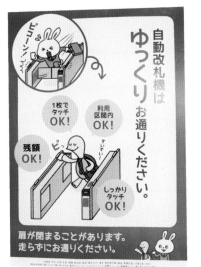

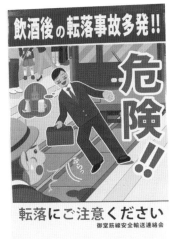

Sampuru サンプル
FAKE FOOD

Sampuru are plastic food models that fill the display windows of restaurants in Japan. Invented in 1932, they make it really easy to choose where to eat! Sampuru can also be purchased in the Kappabashi neighborhood of Tokyo. They make fun souvenirs!

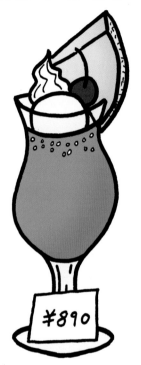

¥890

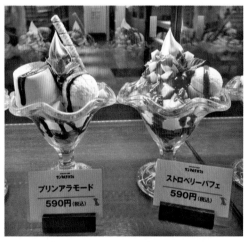

プリンアラモード
590円(税込)

ストロベリーパフェ
590円(税込)

¥870

¥950

Cuteness is everywhere you look! Every day, and in every way, the kawaii aesthetic permeates through the fabric of life in Japan. For visitors it can be a bit of a culture shock to see so much cuteness, but I love it!

Cars, trucks, vans, and even some construction vehicles can look quite different in Japan. Pastel colors, cute logos, smaller sizes, and unique shapes are common features of everyday vehicles and road signage too!

Mascots, also known as yuru-kyara are hugely popular in Japan and are often used to promote tourism as well as organizations such as the police and fire department!

Cute and funny logos are used for every kind of product and business. On the street and in the shops, those who pay attention will be inundated with cuteness!